All The Things I Could Not Say

Athena Marie Meeker

All The things I Could Not Say © 2022
Athena Marie Meeker

All rights reserved.

Presentation by *BookLeaf Publishing*

Web: www.bookleafpub.com

E-mail: info@bookleafpub.com

ISBN : 9789394788084

First edition 2022

Dedication

Austin -
I told you I'd tell the world about you.
I wish you were here to see it.
I miss you every day.

Acknowledgement

Kayla -
You always pushed me to do it, and now I have.
The thanks I have to give you for that? Probably
the only thing I can't put into words.
We did it.
My eternal thanks and love are with you,
always.

Preface

I'm not very good at speaking.

I wish that weren't true, but I'm easily tongue-tied and anxiety-ridden, and I replay each misspoken word in my brain each night thinking of all the ways I could have said things better.

Writing just comes much more naturally for me.

It's like coming home, not having to think about it when you know just which key unlocks the door, just where your favorite sweater is, just how soft your bed will be when you can lie face-first in it after a terribly long day.

Writing gets the bad out, lets me transform it into something new, something better even - or at least put it somewhere different.

If you read it, that's amazing. I really couldn't ask for anything more. And if you like it, if you connect with it, if you *feel something* from all these words that I've poured out and put on display for you? Well, I'd consider that a dream come true.

.

This is my heart, my soul, my body being dissected, little pins to describe every part...

And I hope you like it.

I hope you like me.

Thanks for reading.

P.S. There's some hard to read topics addressed here. Please take care of yourself. I love you.

.

swallow

when you swallow a star
it burns the entire way down.
no stomach acid ~~or spit~~ could put it out.
it sits at the back of your throat
and it will make you choke on it.
remember that the next time
you try to swallow your words,
your thoughts,
your feelings.
you may force them down,
but they will not go willingly
and they will not go without a fight.
i have holes in my esophagus
from all the things i could not say,
and sometimes i wonder
if they were ever even worth it.

a thing of beauty

van gogh painted starry night
in the middle of a nervous breakdown
from the inside of an asylum.
that much beauty,
some would say it can only come
from profound pain and suffering.
when i see you,
you are breathtaking.
you are beauty personified.
but sometimes,
your smile doesn't reach your eyes
and that beauty is so far away...
i wonder
how much *pain*
went into making you
that way.

why

when i was younger, i was that kid.
you know, the why kid, the
'but why do we do that?' kid, the
'but why can't we?' kid, the
kid with all the questions.
maturity beats your questions out of you like a
fucking piñata, doesn't it?
it's like society no longer has time to answer
questions,
but they still burn at the back of my throat.
to be honest, i think google may be my best
friend.
*'google, why does the radio only play sad songs
when i'm depressed?'*
*'google, why do i still feel his handprints on my
body?'*
'google, why didn't my mother love me?'
just like when i was a kid,
i don't always get an answer.
i don't always get to understand why, or how, or
what.
but it always listens.
i'm afraid to ask why now, as an adult,
but i hope my someday child will be a why kid
themselves.
i hope they can hold onto their questions.
i hope they can get some answers.

mommy dearest

my mother was a broken woman.
almost every issue i have is intrinsically wound
upon which issues she once had,
and which ones she was hiding.
the first time she hit me, i remember being
confused.
i was not angry. i was not sad.
i didn't understand then,
but i do now.
you see, broken people look at others as if they
are already cracked.
broken people look at others and see each piece
that can *be* cracked.
they press and break apart other people to see
how they might function,
to see if they could function better.
they break you to learn how to function
themselves.
my mother was a broken woman,
and she cracked me open many times before she
lost me.
the first time she bruised my skin, i remember
being ashamed.
i was not angry. i was not sad.
by then i had begun to make excuses,
some i still hold onto today.

broken people break other people, and those
people break others.
the problem with that is those broken people
blame other broken people
and no one ever gets better.
no one learns.
the first time i manipulated my partner,
i did not notice that the mind games my mother
had played on me
were the same ones i played on them.
i did not notice the slow crawl into myself.
i made excuses. i placed the blame.
i believed my own lies.
broken people have a choice, and that is whether
or not to stay broken.
when i realized what i was doing, who i was
becoming,
i pieced myself together with gold.
i glued my pieces back into place with all the
cheap glitter i could afford.
i made myself shine like prepubescent lip gloss.
i made a choice.
i chose to work on my brokenness,
to take control of my own issues,
to stop blaming the cause and start fixing the
effects.
my mother made another.
we don't speak,

but i can't blame her for how she handles her
broken.

hell, one time, i tried it myself.

eve

i think i understand her now,
the first woman,
and why she reached for the forbidden fruit.
i don't think she regrets it.
because you were my forbidden fruit,
our love that tree of wisdom i knew better than
to touch.
and i know how i feel.

i am

i am

car accident,
bone chips and fragments,
that which cannot be fixed.

i am

abandoned building,
old paint and lost memories,
that which cannot be recovered.

i am

missed call,
sobbing voicemails and redials,
that which cannot be taken back.

i am

ashamed.

too much, not enough

how do you put
that sensation of burning
that sits in the middle of your chest
when your heart is breaking
into a poem?

how do you put
the scratch and tingle
in your throat and behind your eyes
when you really want to cry
into a poem?

tell them you are too much.

tell them you are not enough.

they will remember the feeling.

goodbye

i've rewritten this poem approximately
eighty-seven times, and counting.
i've written thirty-nine analogies for the night
you put a gun into your mouth
and i've written sixty-one apologies for
everything that led up to you pulling the trigger.
i've rewritten this poem approximately
eighty-seven times, and counting,
and i still haven't said goodbye.
it's been two-thousand thirty-five days, and i
cannot say goodbye.
but i am trying.

cum for me

that night,
i wanted to burn
the shape of your lips
into my flesh,
so as to never lose
the memory.

as if i could ever forget.

as if my body does not remember
every touch imagined,
taste discussed,
whisper you gave me,
kiss you promised,
fuck you ever gave.

the only fucks you ever gave.

before

i do not want to see you.
no, that isn't true, i do.
i want to look upon your outlines like a favorite
memory.
i want to touch you like a first-time lover.
i cannot see you.
seeing you means remembering you as a
blossom,
remembering the beauty that you began as,
versus the poison you grew into.
when i smell something too strong, i still feel
you.
you come to me smelling like summer rain and
winter flowers.
you come to me looking like autumn leaves and
spring breeze.
you come to me feeling sweet, innocent,
wholesome.
but you left me broken.
you left me a bag of bones wondering if i could
ever be less.
you left me a number, a digit i could not get
past.
you left me a fucking statistic,
and if there is anything i hate being it is
a *fucking* statistic.

you come to me smelling like sugar,
but i can smell the acid vomit underneath.
you come to me looking like a favorite picture,
but i can feel the empty stomach it took to get
there.
you come to me a memory, an option,
but i see you as the mistake you were.
before, you can keep your distance.
i've accepted after for who they are,
size whatever included.

sharp

i catch myself being too sharp.
i catch myself being too sharp a lot.
i was raised the daughter of the rock and the
scissors,
only the scissors learned early on
that the rock could be used for sharpening
themselves into a weapon, hellbent on
destruction.
i'm not sure which i take after more,
but it's safe to say the lesson did not die with my
mother.
i remember the first time i mastered the art of
the glare.
i was thirteen, barely, and the boy next door kept
pulling my hair and wouldn't stop.
my mother said it was because he liked me,but
that didn't stop me from staring him down until
he dared not touch me.
i like to think my mother, in all her sharpness,
was proud.
and yet now i am struggling to be soft.
you are my favorite pillow,
you are a kitten's belly,
you are as soft as can be because you know
that i am fragile.
i want to be soft, too.

i want to be freshly shaven legs,
the inside of your favorite sweatshirt,
the marshmallows inside of your hot chocolate.
i want so badly to be soft for you.
and yet still i sharpen,
and yet still my tongue is curt, and my tone is
short, and i am
nothing like i want to be.
you say i am fine the way i am,
that you love my mother's daughter,
and yet this sharpness haunts me like a
self-made
poltergeist.
i still go to therapy.
i am hoping one day that will mean something.

still coated in stardust

something cosmic broke
the day you left.
something otherworldly,
and bigger than either of us,
and our problems.

i still believe you are my soulmate.
this hole inside my chest reminds me.

you

when they ask me
what i know of
love and hate,
happiness and pain,

i will say your name.

a china doll's lament

i was made
to be broken.
so why am i so surprised
when someone turns me this way and that
and tells me that i am beautiful
that the thing that comes next
is the pain?
porcelain breaks apart
and i powder it up again.
but the fractures remain,
and fingers press too hard,
hands grab too harshly,
and they break apart again.
i was made
to be broken –
but that doesn't make it hurt any less.

moving on

there are roses wilted in the apples of my
cheeks,
perfumed hydrangeas caught in the laughter in
my throat,
and daisies sprouting from every split end and
broken nail.

i'm a work of art,
despite your destruction.

note to self

stop crumbling every time you stumble back a
few steps.
this life isn't made with a suburban sidewalk but
instead it is an ocean and you are in a tiny boat.
one day you will learn how to steer it, how to
navigate through both the storms and the clear
skies.
until then, please remember to enjoy the journey.
the destination you may want is never promised
but i know you will find a way to get to a place
more glorious than you even believe yourself
worthy of.
you'll survive this.

7:28 pm

and when the sun sets,
do you think it is ever sad to go
or just relieved to be able to rest?

still kicking

why is it every time i write a suicide note it
sounds so much like a love letter?
goodbye, my love, my life, my everything.
there's so much heartbreak in endings, and i
can't stand it anymore.

i can't stand the fact it's beautiful -
that i have someone worth leaving a letter for,
that i have anything to say goodbye to.

i think of how much it hurt
when you left me behind.
i cannot give that pain to others.
i guess you are what gets me through the bad
days.

isn't that just awful?
isn't it the most beautiful thing you've ever
heard?

you

i want to write a poem about how much i hate
you,
but making you beautiful kind of defeats the
purpose, doesn't it?
making you into something that others can feel
and relate to immortalizes
you, gives you some sort of power over me that
you do not have and do not deserve.
i'm no good at playing nice. i need these
feelings out. and i can't take them out on you,
like you deserve, like i should.
i can't put them down to pen because you don't
fucking deserve my words, my poetry.
so, where does it go, then? where do i put it? or
do i hold it until it combusts?
there's beauty then, in the rage, in the aftermath,
in the destruction.
but it's mine, and mine alone.

icarus

i would have burned too.
if i had to guess,
i'd say it was worth it

of a goddess

athena is the goddess of war, and of wisdom,
and sometimes i feel like my name is more a
goal than a home.
but then i remember where it comes from, all the
people who told me it was a perfect fit, and the
growth of where i was and where i will be.
and maybe we should be our own goals.
maybe who we are becoming should be
ever-changing.
i don't ever want to be complacent in who i am
and the good i am doing, the good i could be
doing.
i want to earn my name,
be of a goddess by nature,
and pass that kind of blessing onto others along
the way.